ideals®
CHRISTMAS

*May your home be filled
with the magic and joy of Christmas
and may your hearts be filled
with love and warmth.*

—AUTHOR UNKNOWN

ideals®
NASHVILLE, TENNESSEE

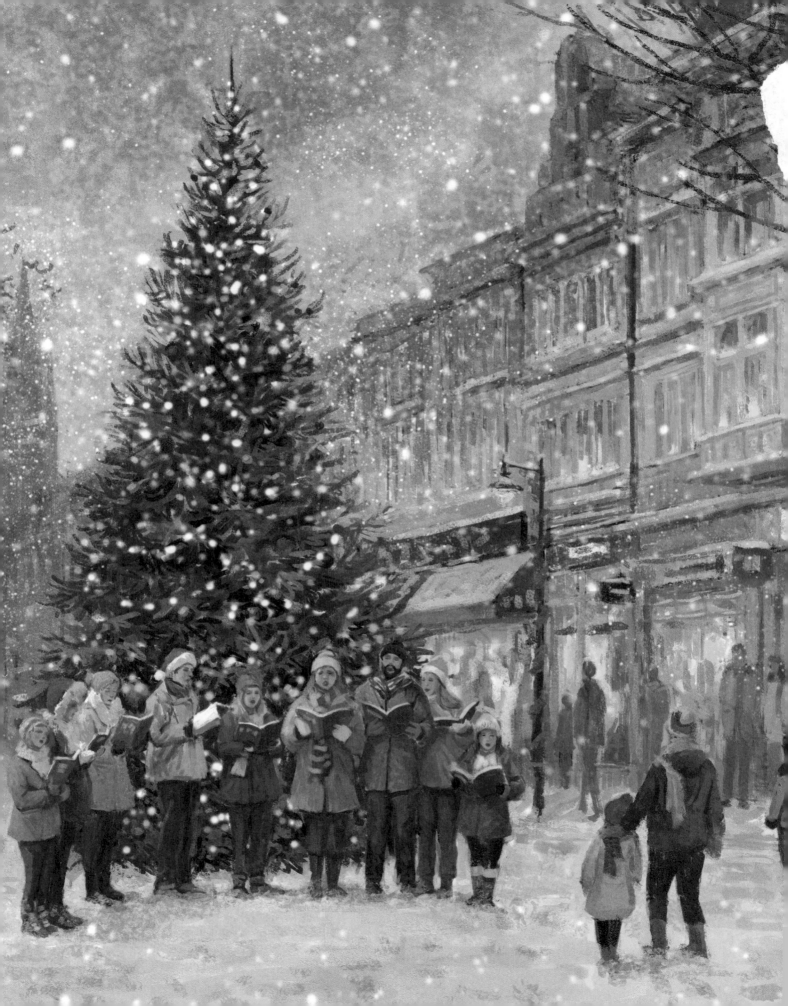

It's Christmas

Garnett Ann Schultz

Christmas is a magic time
when all the world is bright;
it finds a place within our hearts
and fills us with delight.

The world is much more beautiful,
a richer, softer glow.
It seems that God is reaching down
to touch each soul below.

Christmas is a happiness,
a day of hope and peace,
when everyone is kind and good
and worries seem to cease;

a time of love and blessedness,
remembrance fond and dear—
a childlike faith is ours again
this precious once a year.

Christmas Card Town

Vera Hardman

Our town looks like a Christmas card,
glistening, happy, bright;
for feathery, star-like snowflakes
have fallen through the night.

The bushes all wear lacy scarves;
the trees are cloaked in snow;
winter's magic is everywhere
and hearts are all aglow.

Just like a lovely Christmas card,
the message this day brings
is "Peace on earth, good will to men,"
a thought that makes hearts sing.

CITY CAROLLERS *by Daniel Rodgers.*
Image © Daniel Rogers/Advocate Art

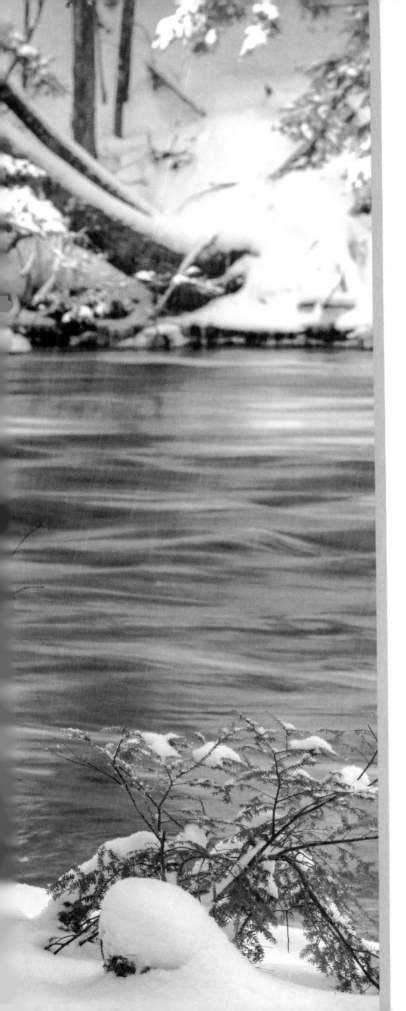

When Winter Came to Call

Mildred L. Jarrell

A silver world was all about
when I awoke this morn,
for overnight the silver frost
of winter came along.

An ermine robe was draped around
the stately evergreens,
and tatted lace of frost was placed
on frozen pond and stream.

The little brook was silent,
locked in winter's clasp,
hemmed in crystal stitchery
with icy blades of grass.

The meadow lay in silence,
while over all the snow,
wildlings tracked their calling cards
where'er they'd come and go.

A wondrous cloak of whiteness
the snow king laid o'er all,
fashioned from a leaden sky
when winter came to call.

*Snow was falling, so much
like stars filling the dark trees
that one could easily imagine
its reason for being was
nothing more than prettiness.*
—MARY OLIVER

*Mersey River, Nova Scotia, Canada.
Image © Scott Leslie/Minden Pictures*

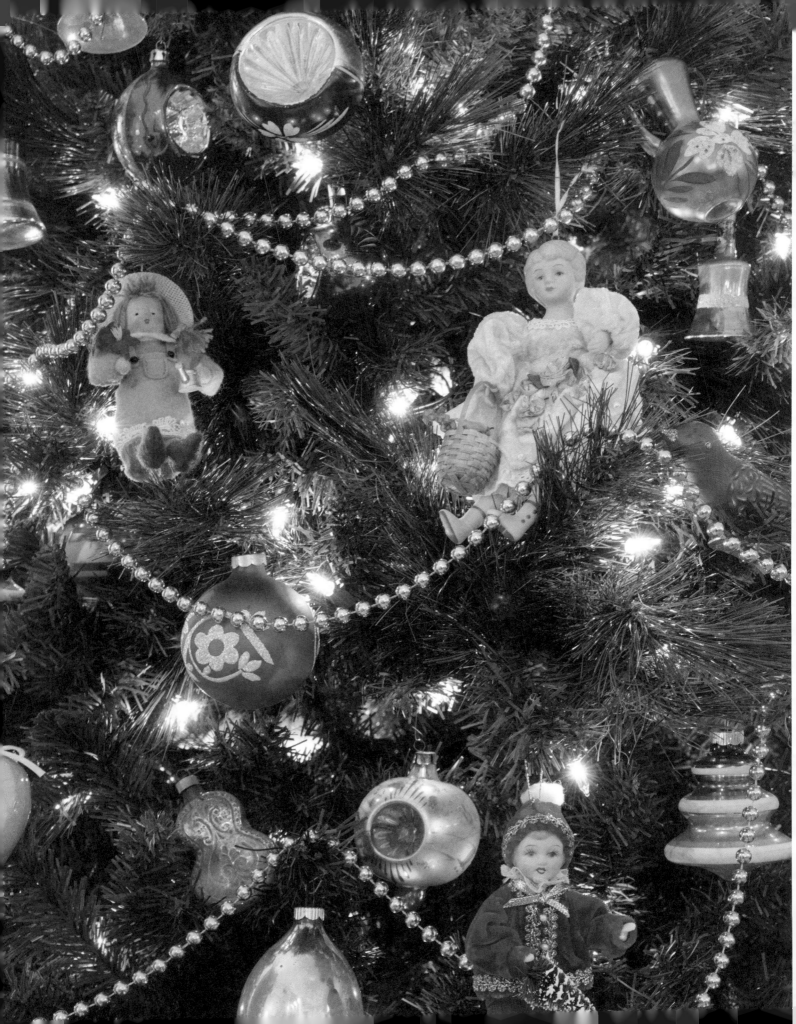

ORNAMENT BLESSINGS

Marilyn Jansen

When our three kids were little, I loved decorating our Christmas tree with them. We made a day of it, picking out a fresh tree, getting take-out food, and turning up the Christmas music as we danced and decorated the evening away. I loved seeing the joy on their faces as they picked an ornament, held it up to me, and waited for me to explain where it came from. As the bottom of the tree filled up with their favorite ornaments, I would dance over and move a few closer to the top to make room for more at the bottom.

"Where this one from, Momma?" one of them would ask.

"That is from your Great-Grandma Jansen," or "that is from Aunt Joan," or "our friend Steve gave us that one."

When they found the ones they had made—glittery handprints or pipe-cleaner reindeer—they would squeal with delight and hold them up. The pride in their eyes always melted my heart. We had one made out of a pancake that made my son break out in laughter. He would often hide it to see who could find it later.

As they got older and left the nest one by one, the tradition changed. I put the tree up by myself more often than not. It was bittersweet to find their ornaments and not have them with me to see that joy and pride in their eyes. But I would smile with the memory and dance as I decorated.

A few years ago, I thought it was time to reimagine the tradition. I knew that decorating was going to be a one-person show from now on, but there had to be ways I could share the joy. I wanted the amazing people who have blessed my tree with ornaments to know how much I love and appreciate their gifts. So I started snapping a photo and texting or emailing it with a note of blessing or prayer to the person who had given me the ornament. There are so many: a handmade hummingbird from my daughter, a set of angels from a friend who recently battled cancer, an old-fashioned Santa from my husband's aunt, an antique glass ornament from a friend nine hundred miles away, and the list goes on. I send notes and they respond with joy and Christmas cheer. Sometimes it leads to video chatting and making more memories.

The connection I have to each ornament goes beyond a pretty decoration. Each one represents a person, a heartfelt gift, a moment in time when we shared love or laughter. Remembering those moments awakens in me the spirit of Christmas. When God sent His Son, He connected us to joy, love, and miracles. Every ornament on my tree is a little reflection of that original Christmas gift. Each is a blessing, a memory, and a connection that has enriched my life.

I thank God for each little piece of Christmas spirit on my tree—even the glazed pancake ornament that, once again, is hiding among the branches.

My Christmas Tree

LaVerne P. Larson

You stand in
 glowing splendor
in our home tonight;
you're dressed in
 shining tinsel
and ornaments so bright,

a radiant star of silver
worn proudly as a crown,

and merry little
 colored lights
that twinkle from
 your gown.

Happy bright-eyed children
gaze at you with such glee,
you're a lovely
 part of Christmas,
my pretty Christmas tree.

Dear Christmas Tree

Jessie Cannon Eldridge

Dear Christmas tree in your holiday dress,
in your wildest dreams did you ever guess,
in your forest home so far away,
that you would be standing here today

with a garland of gold around your waist,
all popcorn and cranberry encased,
with tinsel streamers, a star for a crown,
and all your branches weighted down

by baubles that sparkle and glitter and shine
and brightly colored lights that entwine—
with all our *oohs* and *aahs* and sighs?
I bet it is a great surprise!

Image © Tony Timmington/GAP Interiors

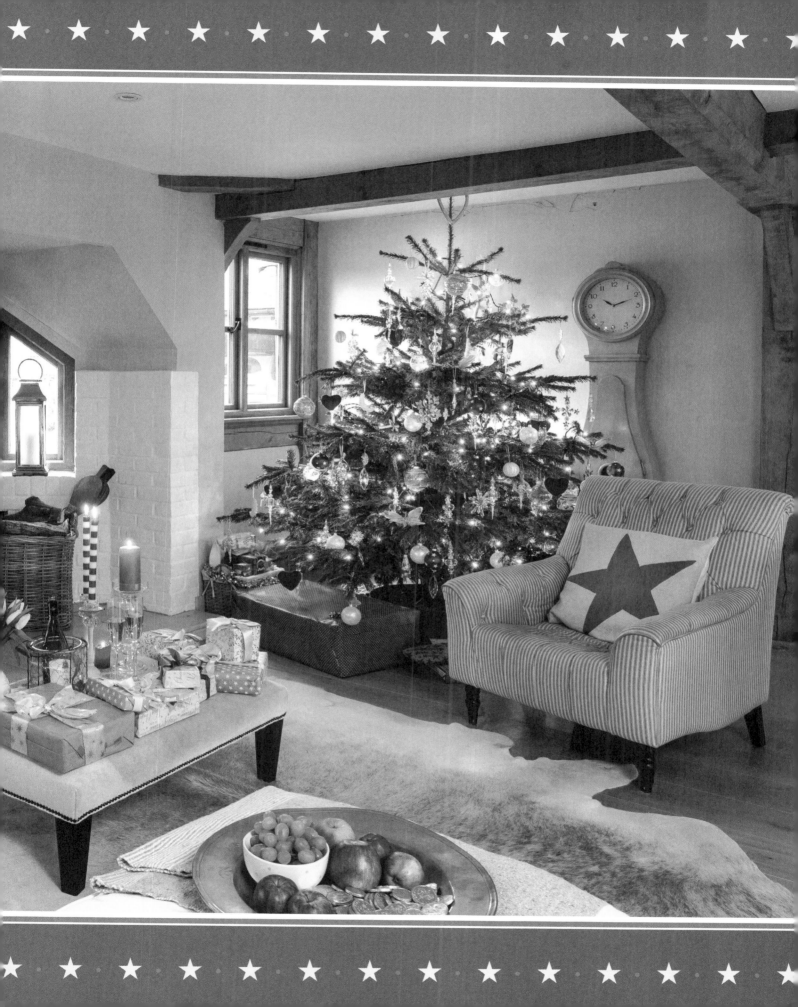

THE SCENTS OF CHRISTMAS

Joan Donaldson

During the Christmas season, certain fragrances float through my home: the woodsy smell of pine needles, the buttery aroma of baking cookies, and the sweet scent rising from beeswax candles nestled in an Advent wreath. When walking through a starry night with other Christmas carolers, the frosty air smells crisp and sharp. I bury my nose in my scarf and inhale the scent of wool and warmth. Because I am a passionate gardener who misses the perfumes of lilacs and violets, I performed a bit of winter magic. A sweet floral scent drifts from the satin flowers of paper white narcissus and lingers in my parlor.

Like purchasing colored lights for decorating a Christmas tree or buying the ingredients for baking cut-out cookies, I had to plan for this perfume. When a bulb catalog appeared in the stack of mail, I ordered the narcissus, envisioning their glistening blossoms and sweet fragrance. Come October, the teardrop-shaped bulbs arrived in a crate holding bags filled with daffodils, crocus, and hyacinth bulbs. Paper whites are native to Greece and thrive outdoors in warmer states like California, but in colder climes like Michigan, they must be grown inside. Because I wanted the bulbs to bloom at Christmas, I pushed the bag to the back of my refrigerator and waited for the proper timing.

In early November, I placed a layer of moist sand and pea gravel in the bottom of a blue-glass pie plate and arranged the brown papery bulbs, marveling how something so small can produce a host of flowers. Now and then, I watered them, but no green shoots appeared. Closer inspection showed slivers of roots emerging from the base of the bulbs, a reminder of how plants need to be anchored in the soil before they can support leaves and flowers. After thickets of roots had formed, tiny green shoots appeared at the tip of the bulbs, and I positioned the container near an east window, anticipating the coming flowers.

There is something magical about tricking narcissus bulbs to bloom in the heart of winter, a season associated with dormant plants, low gray skies, and frozen soil. Little by little the green blades rose higher, enjoying the warm room and the weak sunlight, yet the leaves remained locked together, not showing any sign of future flowers. In mid-December, I spied a cluster of buds covered by a tissue-thin membrane, prying apart the leaves. One by one, each bulb formed buds. On a December day thick with snowflakes, the first narcissus unfurled a constellation of white stars, emulating the blazing star that led the Magi to where Jesus was born. The white blossoms shimmered, defying the darkest time of the year. They reminded me how after the winter solstice, the days would grow longer, the sun would shine more brightly, and the dirt in my garden would thaw.

As each narcissus opened, dotted by a glowing yellow center, its perfume mingled with the smell of wood smoke from the fireplace, with the fragrance from pine branches decorating the mantel, and the aroma from the kettle of potato soup simmering in the kitchen. Although snow buried my farm and I missed my garden filled with fragrant heirloom roses and fluffy peonies, I was grateful for the delicate perfume of paper whites filling my parlor, a humble winter gift to cherish.

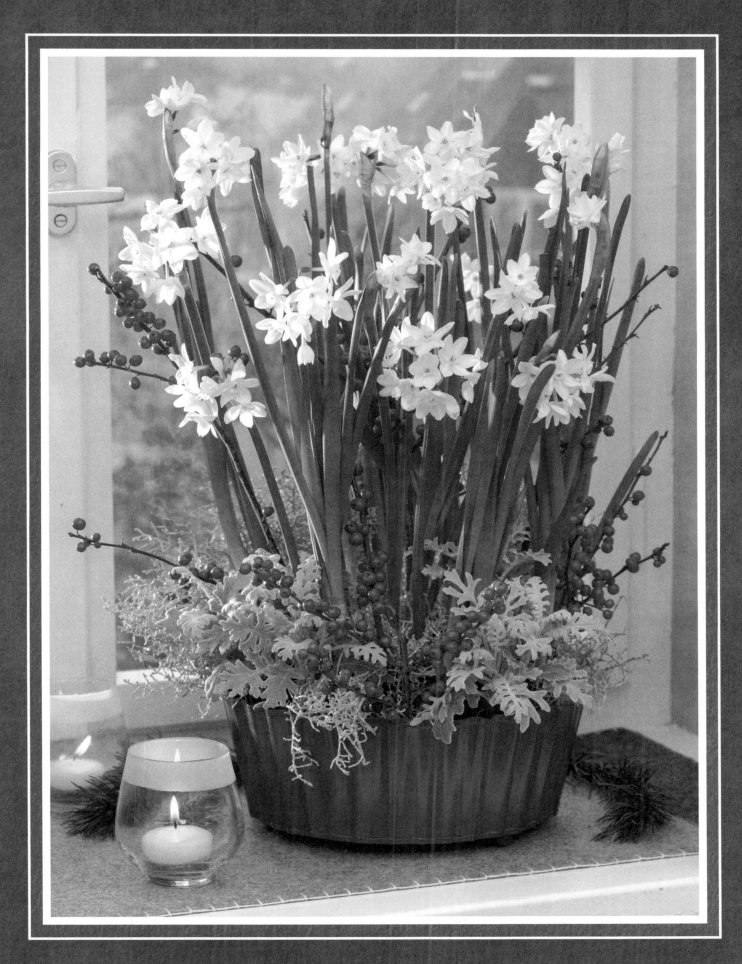

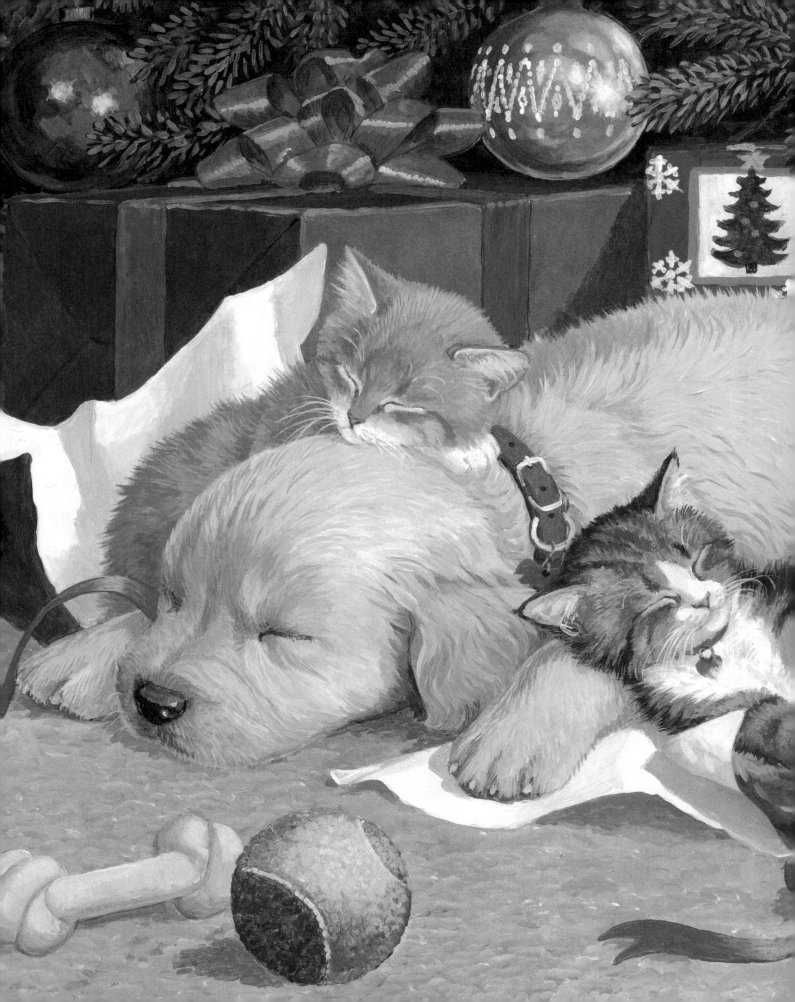

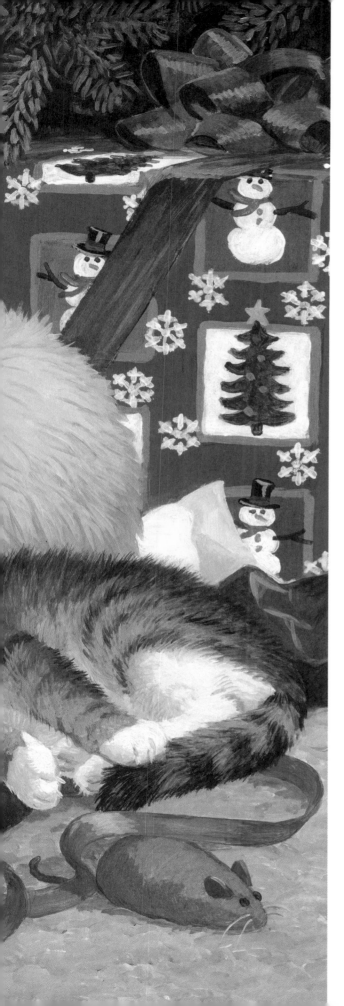

The Shine of Christmas
Lucille Crumley

I love the shine of Christmas—
each glitter bauble on the tree
and every light that gleams
at Christmastime for me.

I love the shine of Christmas—
the candle flame that glows
through clean and sparkling windows
to flicker on the snows.

I love the shine of Christmas—
bright stars in winter skies;
but the shine that's best of all
are the stars in children's eyes.

Simple Joys
Sandi Keaton-Wilson

A cedar bough,
a candle lit,
a rocking chair
in which to sit,

a glowing hearth,
a loving smile,
companionship
to pass the while,

an open book,
a kitten's purr,
simmering pot
to sniff and stir,

a baby's laugh,
a grandma's tale,

a dust of snow
on front-porch rail,

a whispered prayer,
a whistled carol,
a biting wind,
and warm apparel,

a childhood game,
a lifelong friend,
a cheerful card
to sign and send—

these simple joys
are much the reason
for celebrating
the Christmas season.

The Joy and Mystery of Christmas

Rebecca Barlow Jordan

As a child, I could hardly wait until Christmas, especially Christmas Eve. The months seemed endless, and it was ages before the big night—and the moment I had anticipated for so long—finally came.

With stockings hung by the chimney with care and chocolate-chip cookies and a glass of cold milk resting on the mantel, my older siblings and I retired early in the night to our bedrooms—but not to sleep. Behind closed doors, with an ear pressed against the wall, I listened for the sound that would signal the right time. My heart fluttered faster and faster. Then, after what seemed like an eternity had passed, I heard the familiar jingle of sleigh bells.

I threw open the door with such a clatter, I scared the wits out of our sleeping dachshund. "The bells! The bells! Santa has come! Santa has come!" I yelled, beating on the doors of my brother and sister's rooms.

Rounding the corner of our living room, the smell of hot cocoa wafting through the air, we saw our parents standing beside the twinkling Christmas tree and an assortment of shiny new toys. "Santa has come!" they cried, grinning.

We *oohed* and *aahed* over our gifts and listened to my father read the Christmas story from the Bible, then opened our presents, one at a time. I wanted the night to last forever, though I also squirmed, waiting a little impatiently for my turn to unwrap the next gift.

The delight reflected on my family members' faces when they opened their gifts reminded me of the shepherds in the Christmas story we had just heard. As the shepherds met Jesus, the greatest gift, had their faces also shone with joy, reflecting the light of the angels and the bright Christmas star announcing the Savior's birth?

In that moment as a child, I realized that Christmas wasn't just about my world. Experiencing the joy of that special night through both my family's and the shepherds' eyes added another dimension—and made the wait for Christmas all worthwhile.

Later, I also learned the secret of the mysterious bells. Since Santa moves so quietly in his velveteen suit depositing his gifts, then dashes away silently, children can't hear the reindeer hooves on the roof or hear the sleigh bells jingling through the night sky. So my father, wanting to help St. Nick and add to our joy, shook a cluster of jingle bells down the hall to replicate the sleigh bells, so we'd know the jovial Santa had completed his visit.

The joy and magical mystery of those early Christmas days still linger, and my heart is still ready to receive both the gifts and the good news of great joy.

Dancing Joys
Susan Sundwall

The little ones
with eyes so bright
won't fall asleep
too soon tonight.

The dancing joys
inside their heads
are too exciting
for their beds.

They toss about
and long to see
the glory 'neath
the Christmas tree.

But night slips on
and slumber creeps—
snugly posed,
each child sleeps.

Comes brilliant dawn,
unbridled joy,
they pounce upon
each longed-for toy.

Now at last
the happy day
is blessed with
quiet child's play.

Again, 'Tis Christmas
Shirley Sallay

Holly at the doorway,
trim upon the tree,
presents wrapped and waiting—
a lovely sight to see.

The sound of carols being sung,
candles burning bright,
a table set for company,
snowflakes falling light.

Yes, again 'tis Christmas,
that magic time of year,
when peace to all is present
and messages speak cheer.

It sets thoughts recollecting
the days of long ago
and brings a deep contentment,
to set the heart aglow.

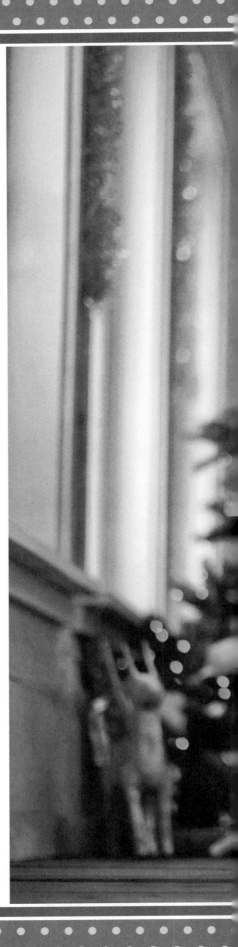

Image © Erickson Stock/Offset by Shutterstock

Image © Svetlana Cherruty/Shutterstock

We have more than thirty tree slices this Christmas. Our now-grown children joke, more than half seriously, that there are too many to fit on one Christmas tree. Perhaps they will carry the tradition into their own homes. Someday there will be tree slices to celebrate new additions to the family. Family is something that lasts forever, and thanks to a timely suggestion all those years ago, so can a bit of each Christmas tree!

Family Recipes

CHRISTMAS PUNCH

2 cups orange juice
2 cups cranberry juice
1 cup pineapple juice

1 cup ginger ale
Fresh cranberries and
 orange slices (optional)

In a 2-quart pitcher, combine juices; stir well. Refrigerate and serve cold. Just before serving, stir in ginger ale. Garnish with fresh cranberries and orange slices, if desired. Makes 6 servings.

SOFT GINGERSNAPS

1½ cups unsalted butter
4 cups all-purpose flour
4 teaspoons baking soda
4 teaspoons ground ginger
2 teaspoons ground cinnamon

½ teaspoon salt
2 cups light brown sugar
½ cup molasses
2 eggs
⅓ cup granulated sugar

In a medium saucepan over medium heat, melt butter, stirring until browned, about 5 to 8 minutes. Remove from heat and cool 15 minutes.

Preheat oven to 350°F. In a large bowl, mix together flour, baking soda, ginger, cinnamon, and salt; set aside. In a separate large bowl, combine brown butter, brown sugar, molasses, and eggs; beat well. Gradually stir in flour mixture, mixing until just combined. Pour granulated sugar into a small bowl. Roll dough by heaping teaspoonful into balls and roll in sugar to coat. Place two inches apart on parchment-paper-lined baking sheet. Bake 10 to 12 minutes, until edges are golden brown. Remove from oven and cool on baking sheet 10 minutes; transfer to rack and cool completely. Makes 5 dozen cookies.

EASY FUDGE

2 cups semisweet chocolate chips
1 cup milk chocolate chips
1 14-ounce can sweetened
 condensed milk
¼ teaspoon salt
1 cup chopped walnuts (optional), divided
1½ teaspoons vanilla extract

In a large saucepan over low heat, melt chocolate chips with sweetened condensed milk and salt. Remove from heat and stir in ¾ cup nuts and vanilla. Pour mixture into a buttered 8 x 8-inch baking pan, spreading evenly. Sprinkle remaining walnuts over top of fudge and chill 3 hours.

Remove fudge from pan and turn out onto cutting board. Cut fudge into 1-inch squares. Cover and store in refrigerator or freezer until ready to serve. Makes 64 squares.

POINSETTIA COOKIES

3 cups all-purpose flour
1 teaspoon salt
2 cups confectioners' sugar
1 cup butter, softened
2 eggs
1 teaspoon vanilla extract
½ teaspoon rum extract
1 cup shredded coconut
1 cup butterscotch chips, divided
⅓ cup granulated sugar
½ cup candied red cherries, cut in wedges

Preheat oven to 375°F. In a medium bowl, sift together flour and salt; set aside. In a large bowl, blend confectioners' sugar and butter. Add eggs, vanilla, and rum extract; blend well. Gradually stir in flour mixture until just combined. Fold in coconut and ¾ cup butterscotch chips. Chill dough 30 minutes or until firm enough to handle.

Roll into 1-inch balls and place 2 inches apart on ungreased cookie sheets. With bottom of a glass dipped in granulated sugar, flatten each cookie. Place a butterscotch chip in center of each cookie, point side down; arrange cherry wedges in a circle around chip to resemble a poinsettia. Bake 10 to 12 minutes, until edges are golden brown. Makes 5 dozen cookies.

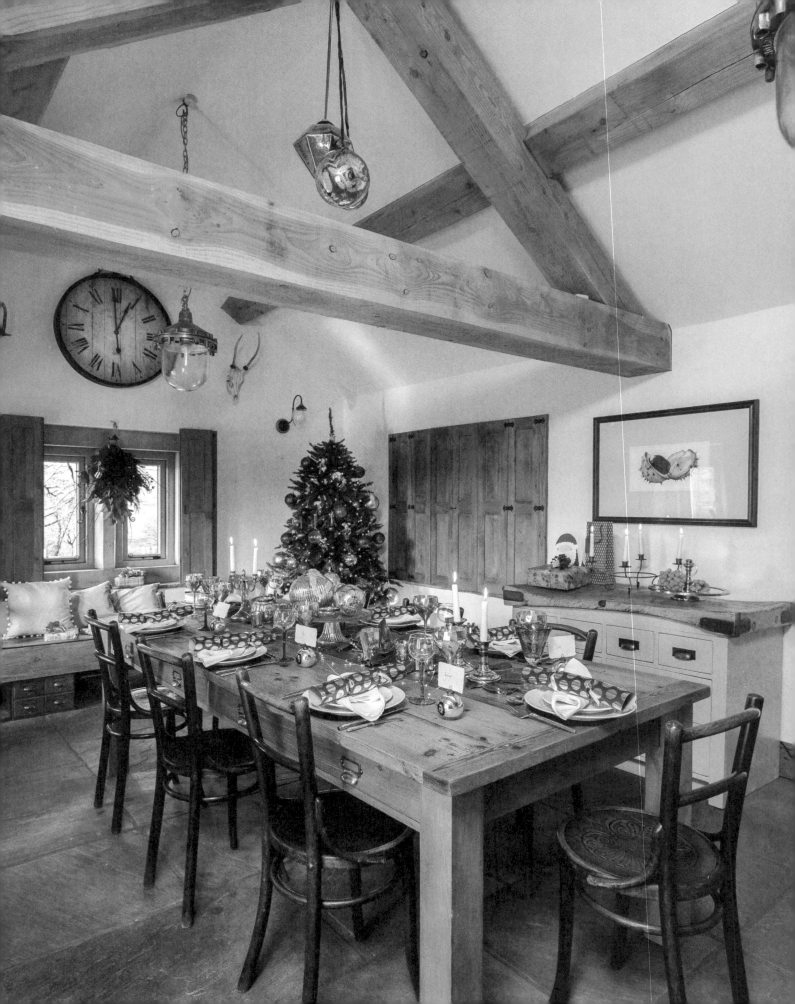

Glad Christmas Day
Dale Cross Purvis

We dust the mantel, sweep the floor,
make a wreath for our front door,
wrap the gifts in green and red,
frost the cakes and gingerbread.

We hang our stockings in a row.
The hearth is warm. The candles glow.
Friends and family on their way.
Soon will be glad Christmas Day.

O Holiday Table
Marta Murray

O holiday table dressed with care,
your china, crystal, silverware
on spotless linens, crisp and white,
invite us to your feast tonight.

O sparkling kitchen
 (not always so),
your counters are filled with
 cookie dough,
apples peeled and sliced for pie,
and cornbread stuffing—moist,
 not dry.

O doorbell, ring! Our friends arrive
and warm themselves by fireside.
We laugh and talk with kith and kin
until the table draws us in.

O lush aromas, drift our way.
Now call the children in from play.
As candles flick their sweet perfume,
we gather in the dining room.

O rich cuisine, before us spread
a succulent roast;
 some homemade bread;
buttered potatoes with
 seasoned gravy;
gelatin mold, all wobbly
 and wavy;
peas and onions in creamy sauce;
rough-chopped salad, freshly tossed;
cranberries mixed with citrus rind;
and bubbling casseroles of every kind.

O holiday table, you're dressed
 with care,
no store-bought goods—
 all hand-mixed fare.
Before we have a single taste,
we all join hands and pause
 for grace.
Our thankfulness will lead the way
to memories sweet this holiday.

Image © Tony Timmington/GAP Interiors

THE CHRISTMAS KEEPSAKE

Clara Brummert

Not long ago, on an afternoon soft with falling snow and warmed by a fire, I snuggled in a quilt and leisurely paged through holiday cookbooks. The fire crackled as hushed carols played, and I sipped peppermint tea while deciding on an assortment of cookies. Then I reached for my grocery list and added the ingredients I needed to buy.

At the top of the sheet, I jotted the word *apricots*, an essential ingredient for our family's favorite holiday cookie. My mother had come upon the recipe for apricot-filled cookies long ago, and she and I had baked them together for years. Back then, rave reviews from our family had quickly turned the fruit cookie into a Christmas tradition. They were always the first to disappear from a dessert tray, and Mom and I soon learned to double the recipe.

Now, years later, I knew the recipe by heart. Still, I reached for my recipe box, drawn to the vanilla-smudged card and the memories it held. As I traced my finger over Mom's lovely handwriting, I smiled at the thought of our holiday moments in the kitchen.

Down in a corner of the card, I'd made a few notes of my own. My cursive writing complemented Mom's fine script, and vice versa, the same as we'd always made a fine team in the kitchen.

Although I was now married and lived several states away, my husband and I always celebrated Christmas with apricot-filled cookies. Perhaps, this year, our young daughter would be ready to learn a few things about baking. I finished my tea, then gently returned the card to its place in the box.

A few days later, I lined ingredients on the kitchen counter, anxious for my daughter to bound down the hall. I propped the apricot cookie recipe card against a canister, and my husband carried a chair to the counter to serve as a stool for our young baker.

Before reaching for flour, my daughter and I studied the words and numbers on the card. Her lips silently moved as she sounded out letters.

"Gram wrote 'eggs'!" she blurted, tickled with her own reading skills.

Her tiny finger referred to the recipe often, and we measured and stirred, then cut tree shapes that I formed into double cookies with apricot filling inside. We shared one from the first sheet that came out of the oven.

"Mmm. Trees are yummy!" she grinned around a warm bite.

Later, I wiped the counter as she played in the sink and filled cups with the suds. We shared the sink as I washed cookie sheets. The kitchen was warm and smelled of baking